T0130378

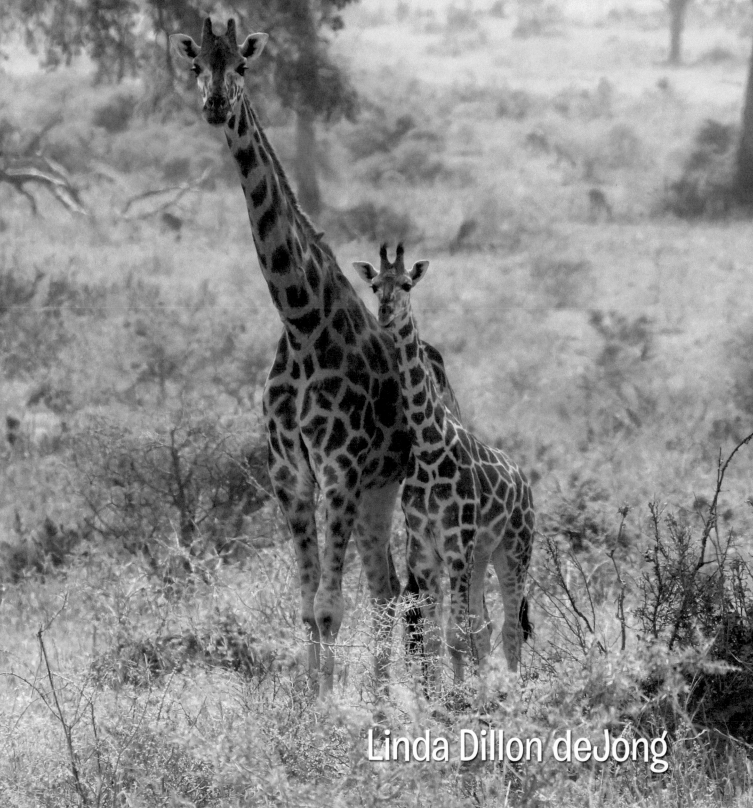

Grandma and Rachel Go on Safari

Linda Dillon deJong

AuthorHouse™
1663 Liberty Drive
Bloomington, IN 47403
www.authorhouse.com
Phone: 833-262-8899

This book is printed on acid-free paper.

ISBN: 978-1-6655-3333-1 (sc)
978-1-6655-3332-4 (e)

Library of Congress Control Number: 2021915302

Print information available on the last page.

Published by AuthorHouse 08/02/2021

Other books by Linda Dillon deJong:
Gideon and Grandma Visit Camano Island State Park
Grandma and Aqelesiya Look for Birds
Grandma and Lilly Explore the Forest

authorHOUSE®

CONTENTS

DEDICATION

This book is dedicated to my beautiful daughter Rachel who traveled to Uganda with me and loves giraffes as much as I do!

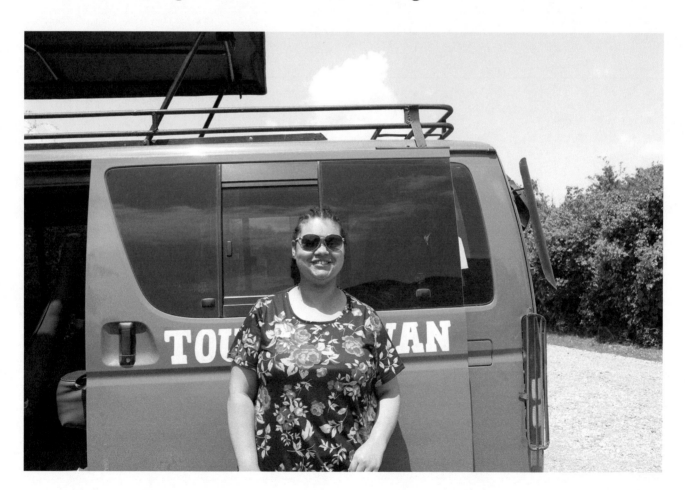

ACKNOWLEDGEMENTS

We appreciate our wonderful Safari Tour
Guide Vicent De Paul Turyakira!

We recommend him to anyone traveling to see Gorillas, Giraffes,
Elephants, Lions, Birds, or any wildlife in Uganda or nearby countries!

turyakiravicent5@gmail.com

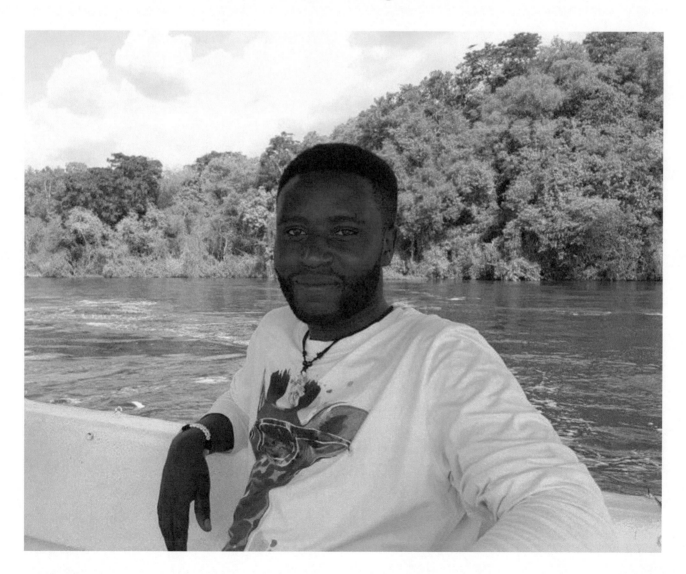

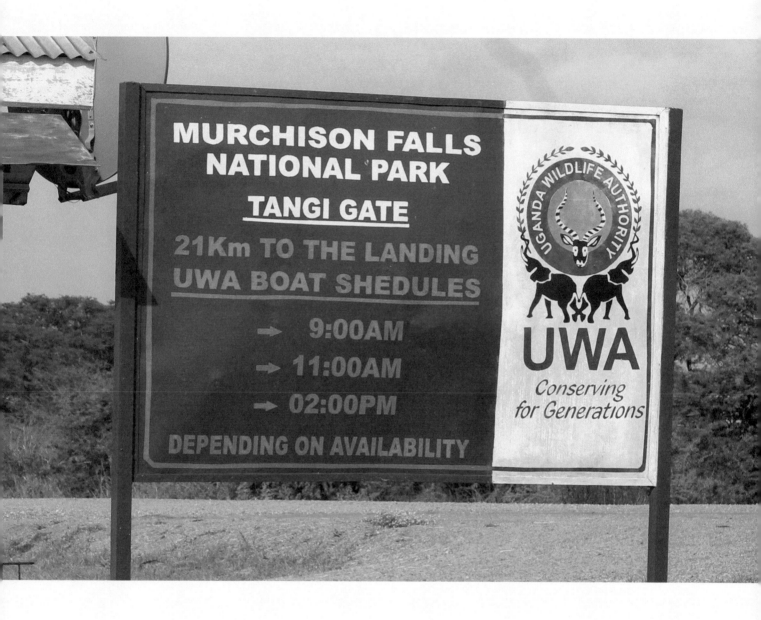

We were so happy to go on a safari in Murchison Falls National Park, the largest National Park in Uganda.

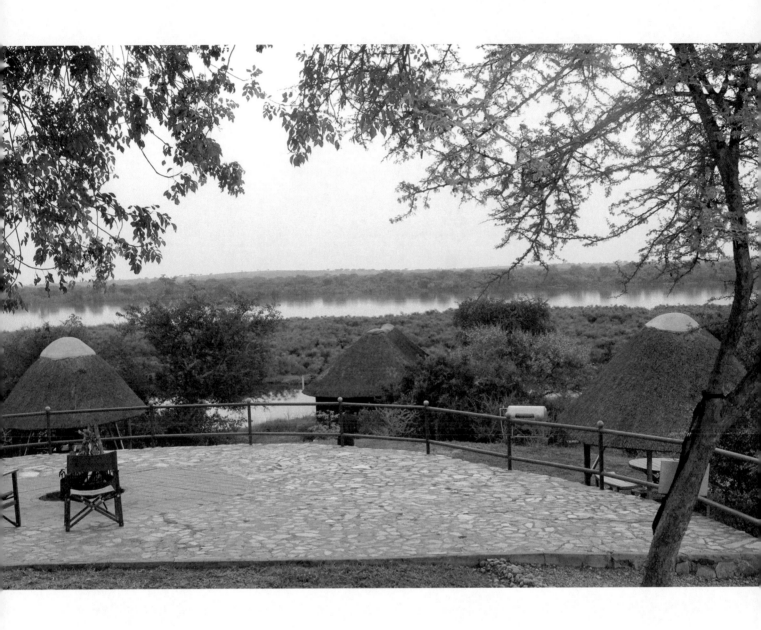

We stayed two nights at the Twiga Safari Lodge inside the Murchison Falls National Park. We loved this lodge located on the beautiful Nile River!

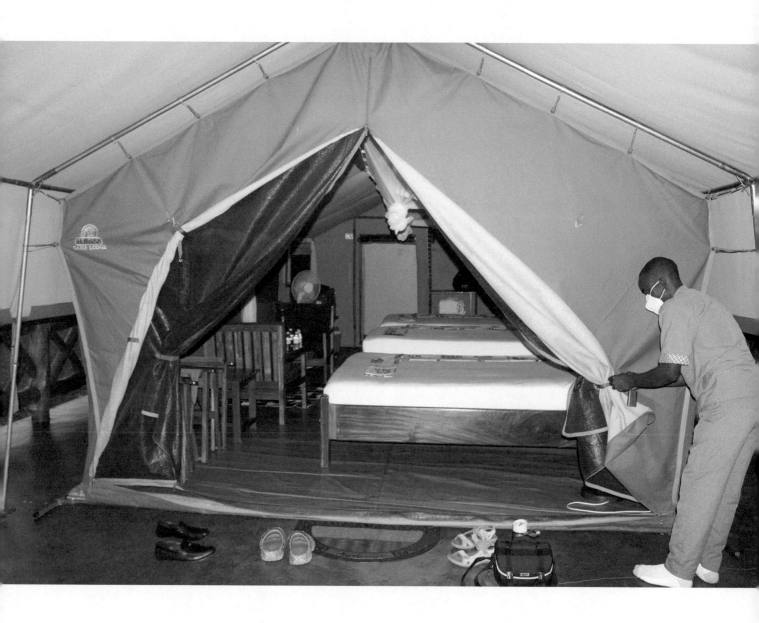

Our tent bedroom where we slept was beautiful and comfortable. We heard many birds when we woke up in the morning. We were surprised to find a full bathroom at the back of the tent!

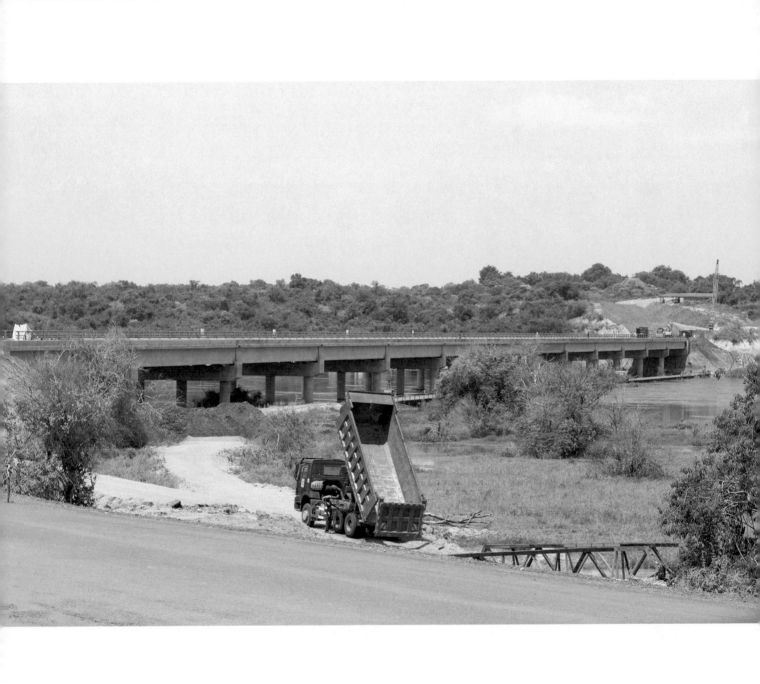

Early in the morning we drove across the new bridge over the Nile River. We were extremely excited about our safari adventure!

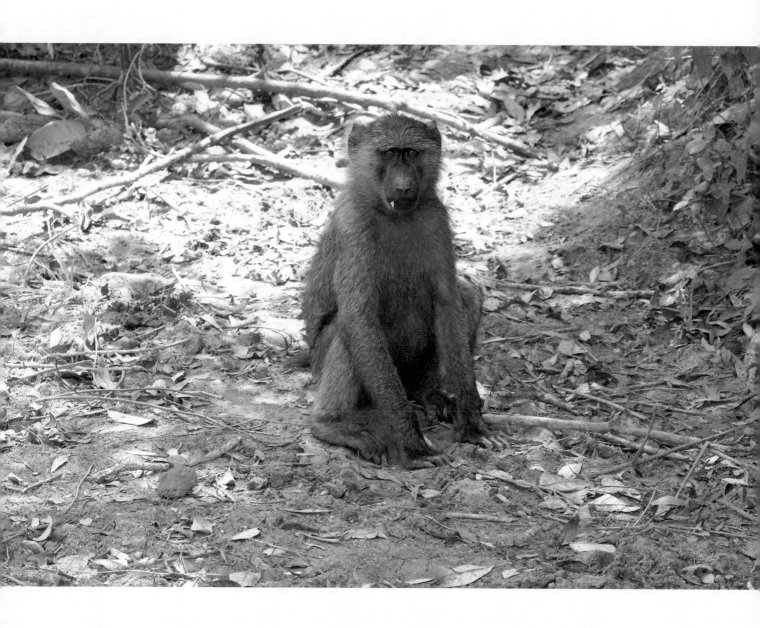

Vicent said, "There is an Olive Baboon sitting over there! They live in groups called a troop. They eat grass, roots, fruit, insects, and small animals."

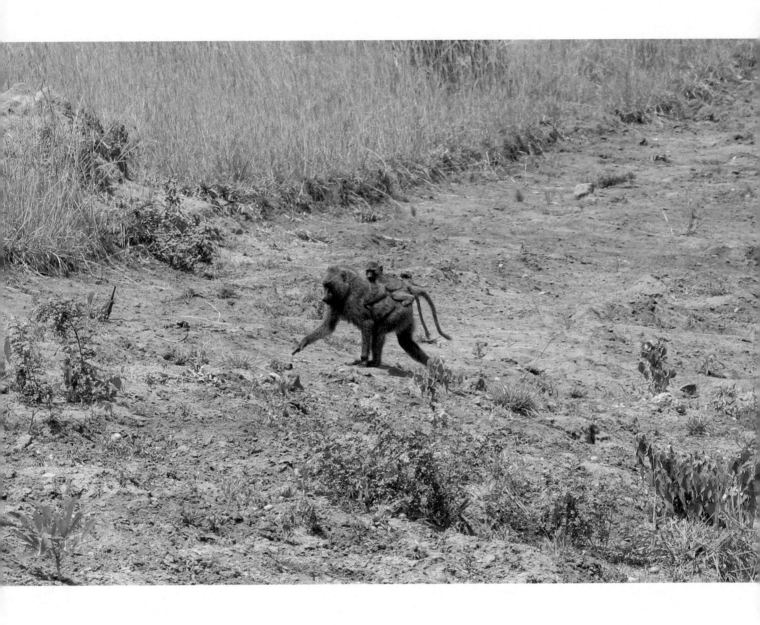

Rachel said, "That Baboon has a baby on its back!"

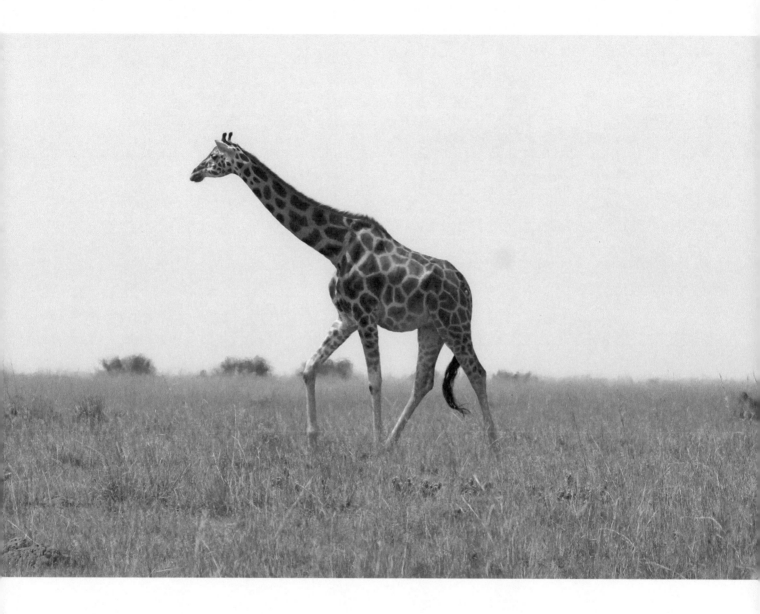

Grandma said, "Rachel, there is a Giraffe!"

Vicent said, "Giraffes are the tallest land animals, and they can be 19 feet high (6 meters). This is called the Rothchild's Giraffe. They have white on their legs that almost look like they are wearing socks."

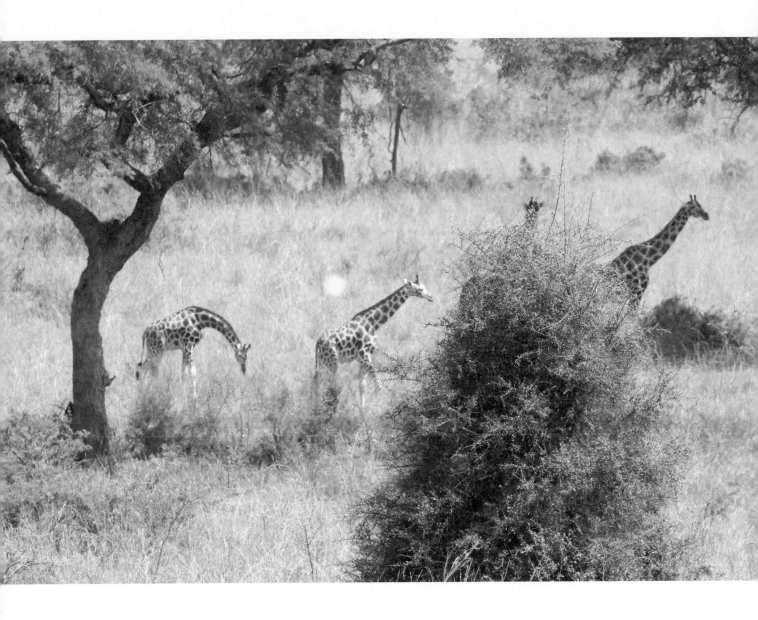

Rachel said, "I see some baby Giraffes!"

Vicent said, "When a giraffe is born, he is already as tall as a grown-up human man. The calf can walk one hour after he is born!"

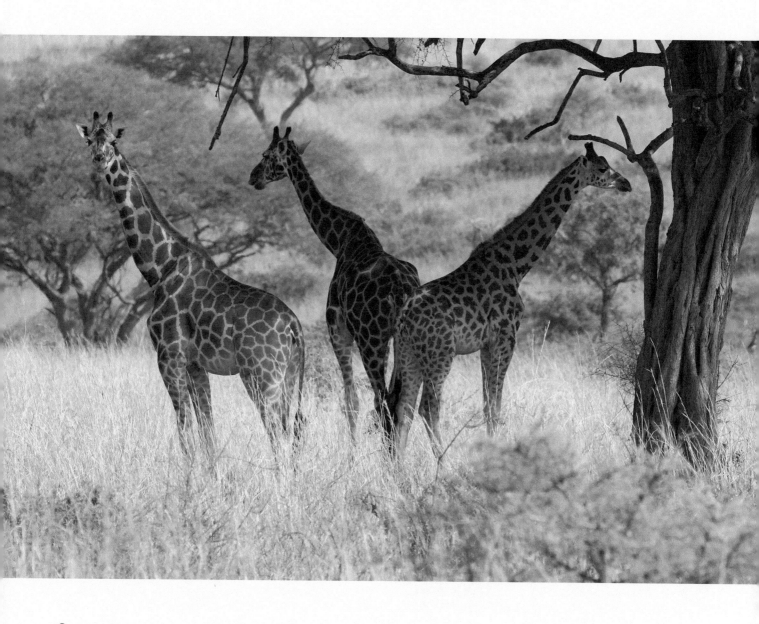

Grandma said, "Oh, those Giraffes are staying cool under the shade of that tree."

Vicent said, "Giraffes eat only plants. Their favorite food is the leaves of the Acacia tree. They use their long tongues to pull the leaves off a branch."

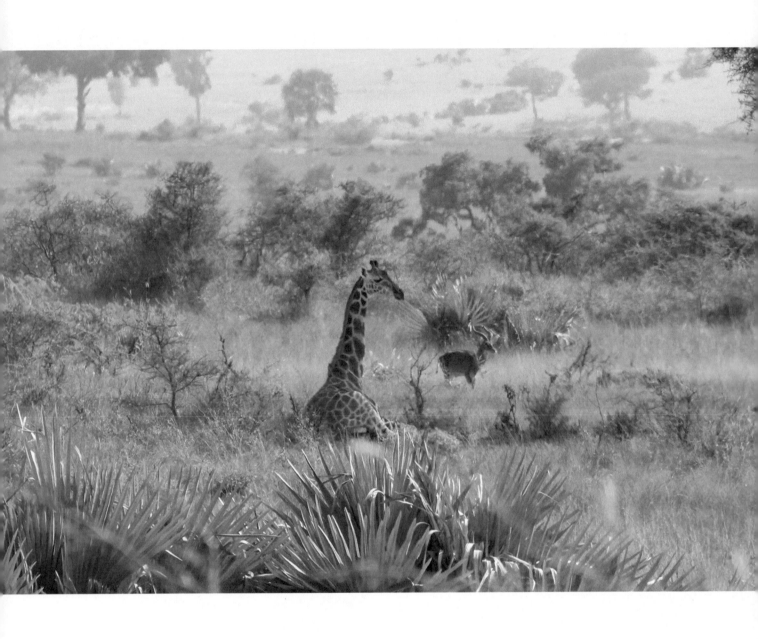

Vicent said, "Giraffes do not need very much sleep. They can sleep standing up or they can rest on the ground like this giraffe."

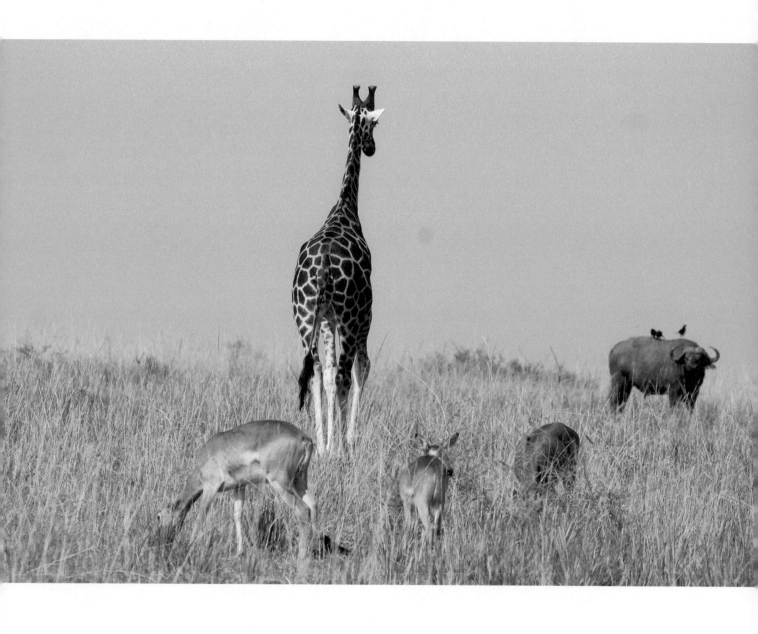

Vicent said, "Other animals feel safe grazing near giraffes, because the giraffes are tall and can see if there is danger before the other animals."

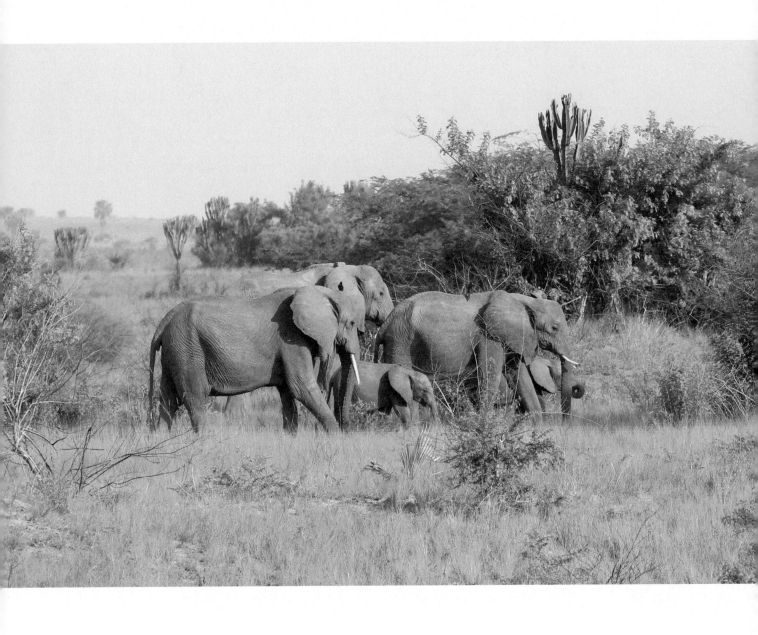

Grandma said, "Rachel, there are some Elephants! One is a little baby."

Vicent said, "They are called African Savanna Elephants. They eat grass, plants and fruit."

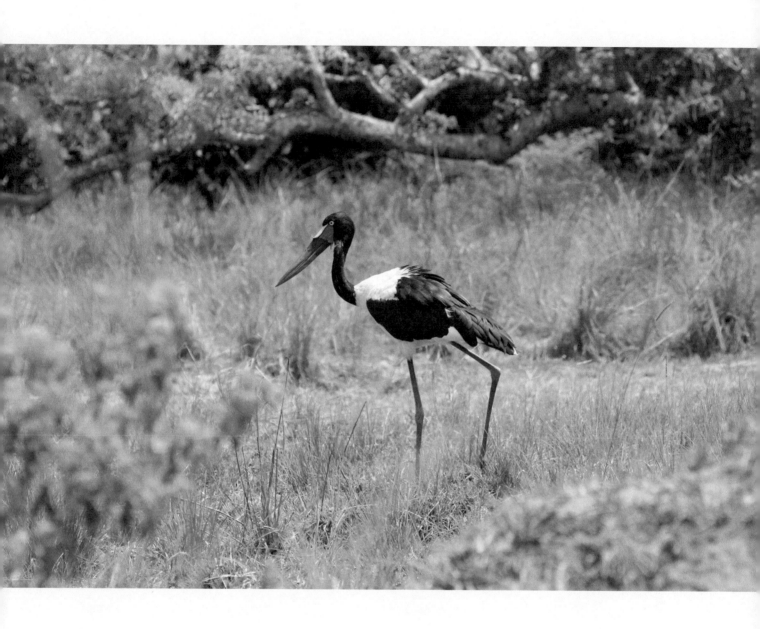

Vicent said, "That bird is a Saddle-Billed Stork. It is one of the tallest birds in the world. It hunts for fish and frogs in the wet areas."

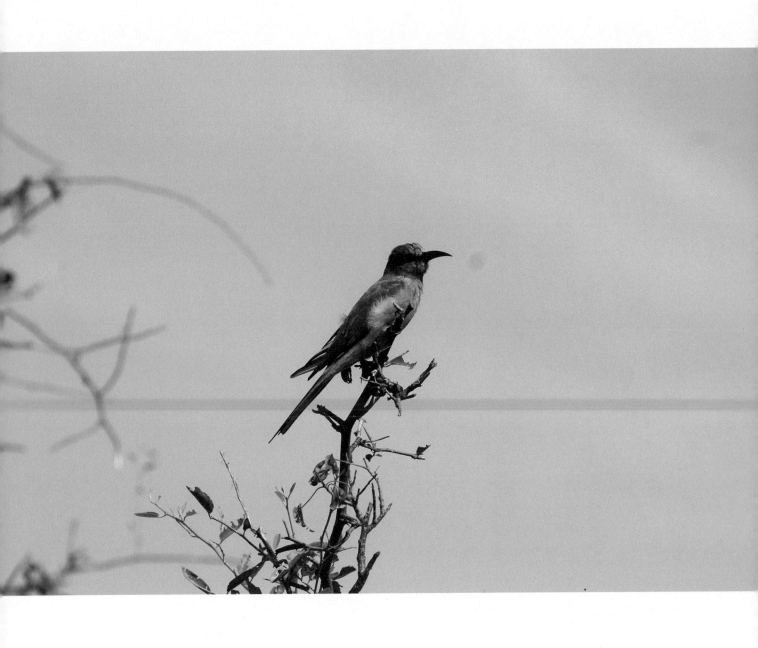

Vicent said, "That bird is a Northern Carmine Bee Eater. They eat bees, insects, grasshoppers and locusts."

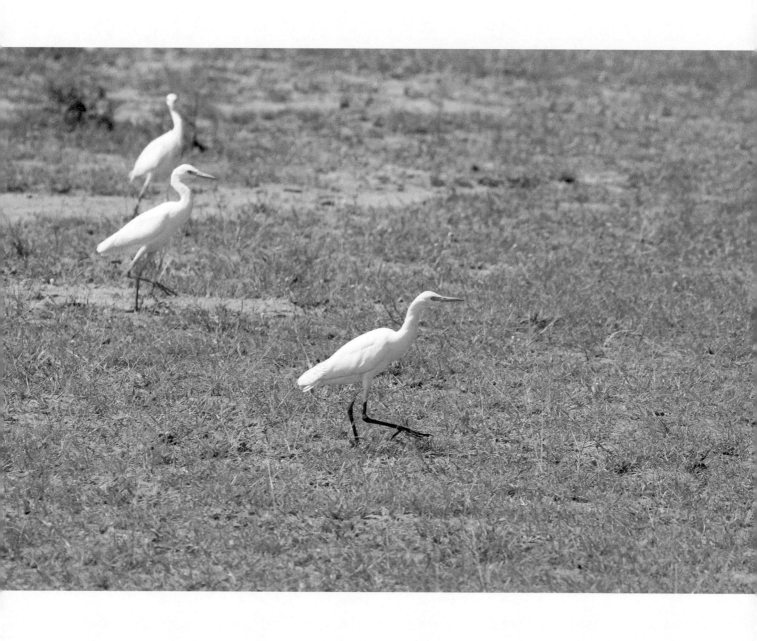

Vicent said, "The white birds walking are called Intermediate Egrets. They are smaller than a Great Egret. They look for fish, frogs, and insects in shallow water."

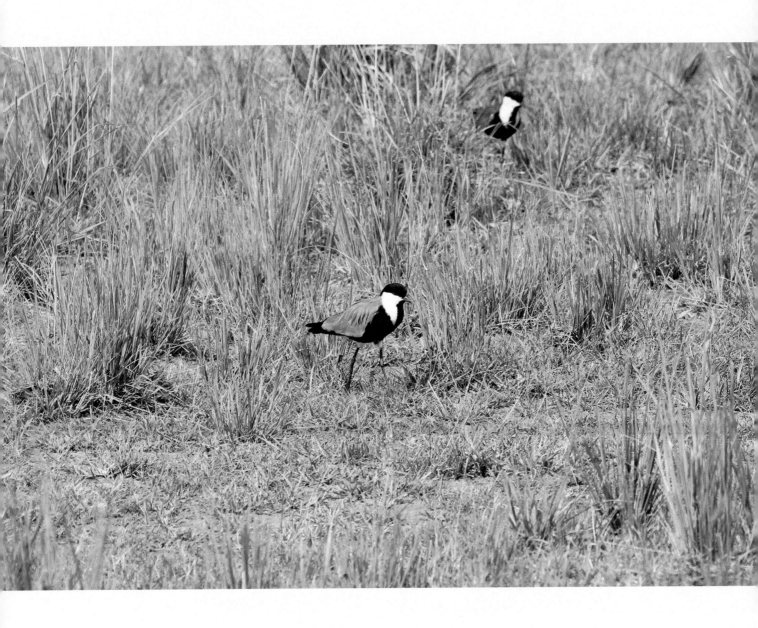

Vicent said, "Those little black, white, and brown birds are called a Spur-Winged Lapwing. They like to walk in wet areas and eat insects. These birds lay their eggs in a nest on the ground."

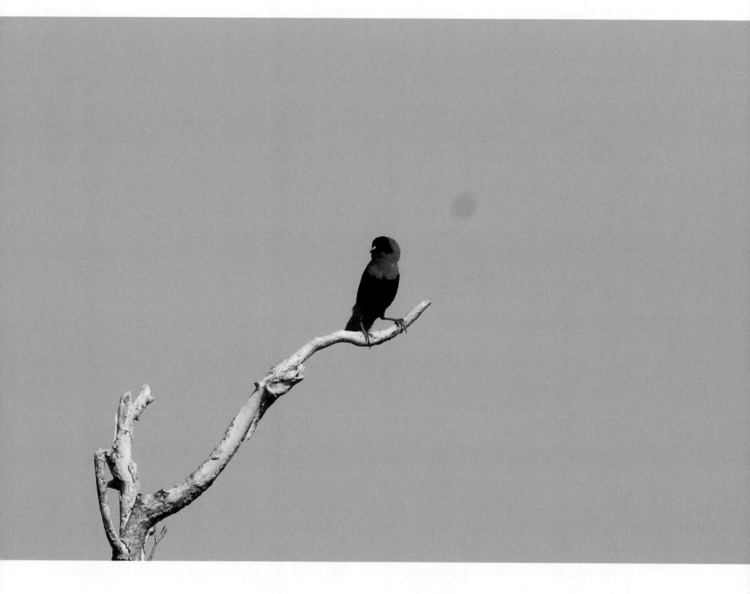

Vicent said, "The small red and black bird on the branch is called a Northern Red Bishop. They eat seeds and insects. The male bird has the red feathers. The male builds a round nest with an entrance on the side. The female adds soft material inside the nest."

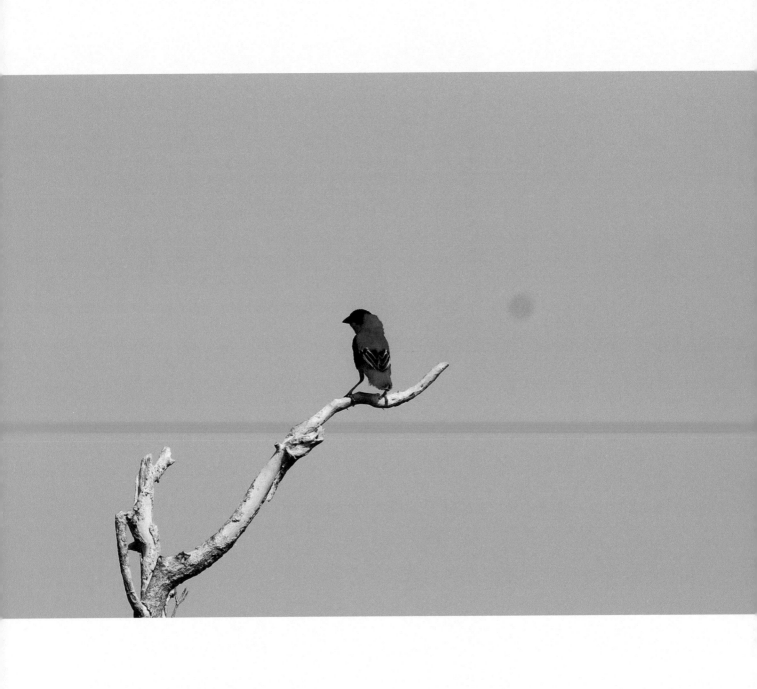

Rachel said, "That bird has beautiful colors!"

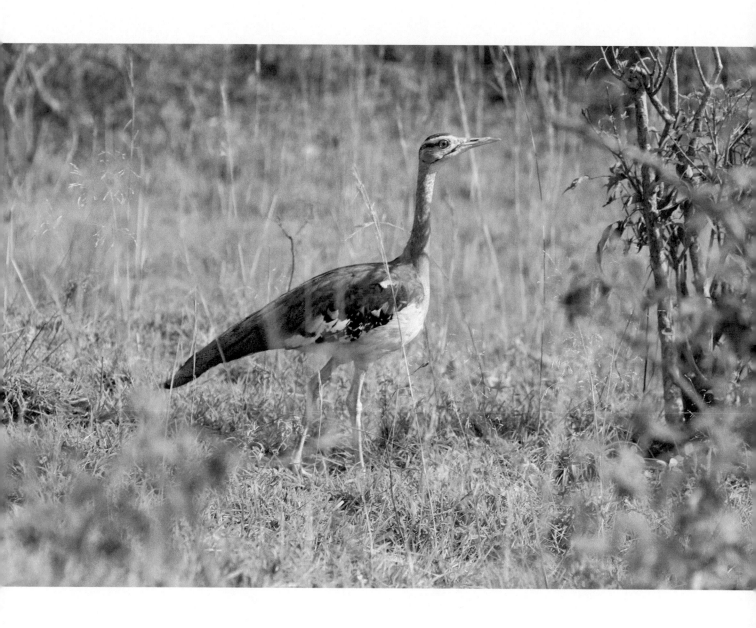

Vicent said, "The bird walking is called a Denham's Bustard. They like to walk where there is water and grass. They eat insects, small snakes, mice, and plants."

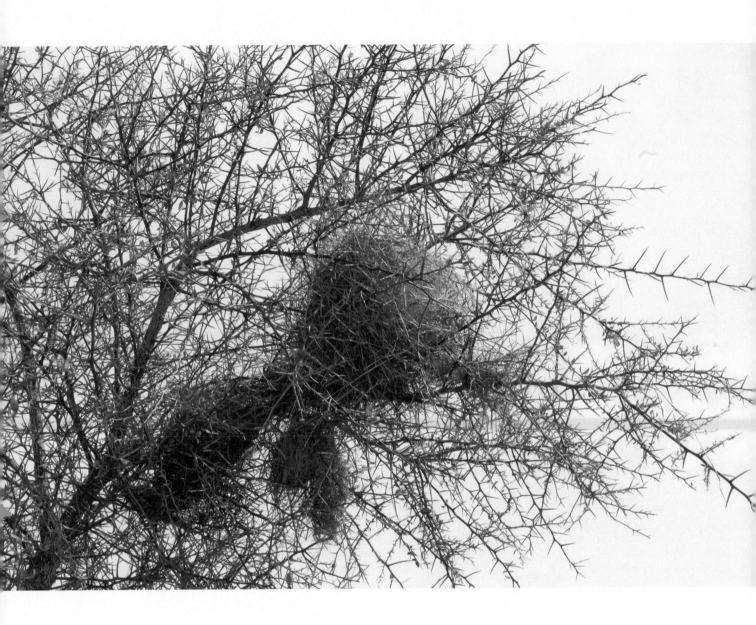

Grandma asked, "What kind of birds made those nests in the tree?"

Vicent said, "Those nests are made by the White-Browed Sparrow Weavers."

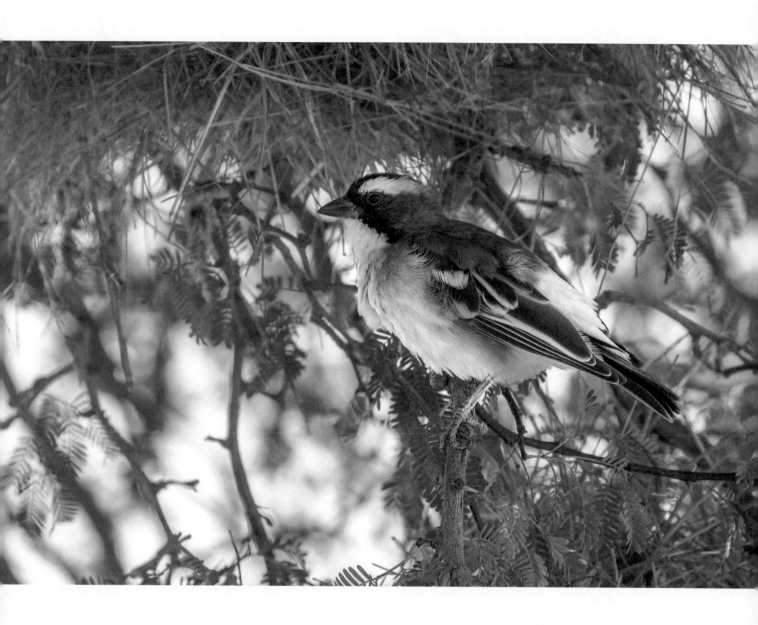

Vicent said, "White-Browed Sparrow Weavers are small birds that eat insects and seeds. They make grass nests in trees."

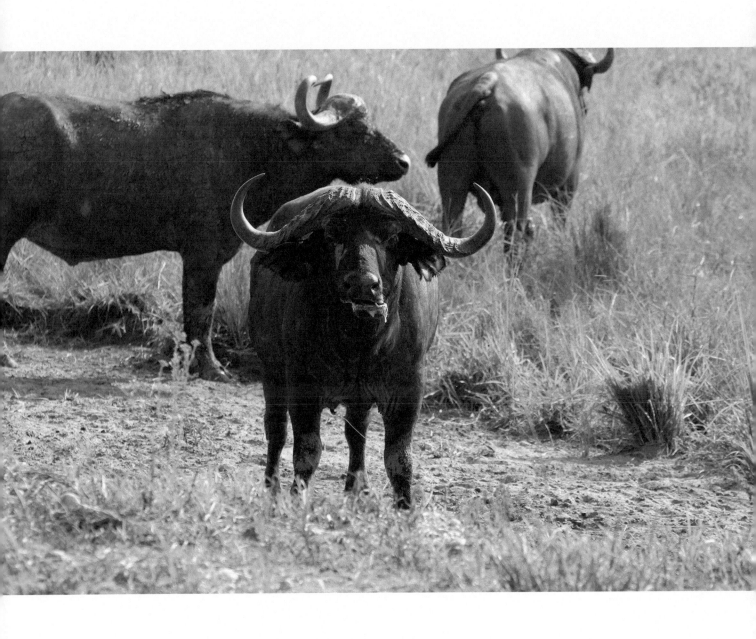

Rachel asked, "What kind of animal is that?"
Vincent said, "Those are African Cape Buffalo."

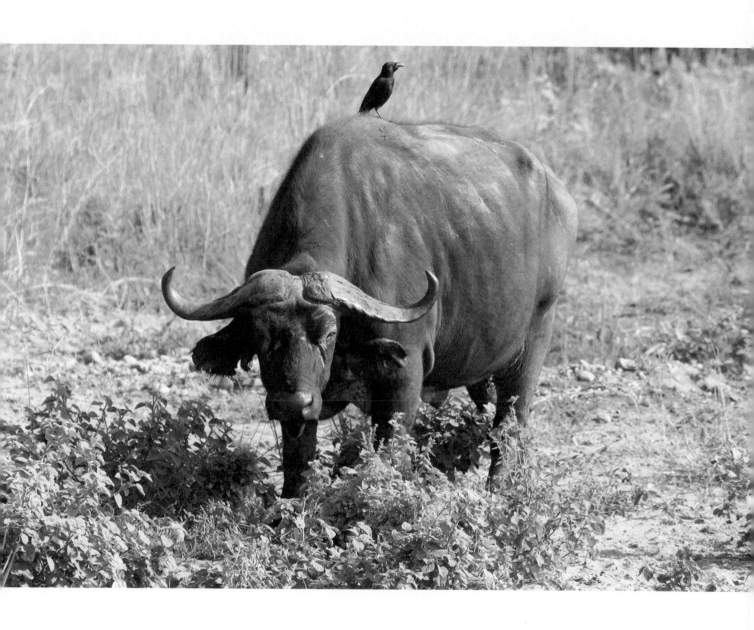

Vicent said, "That one has a Piapiac bird on its back. The bird helps the buffalo because it eats insects."

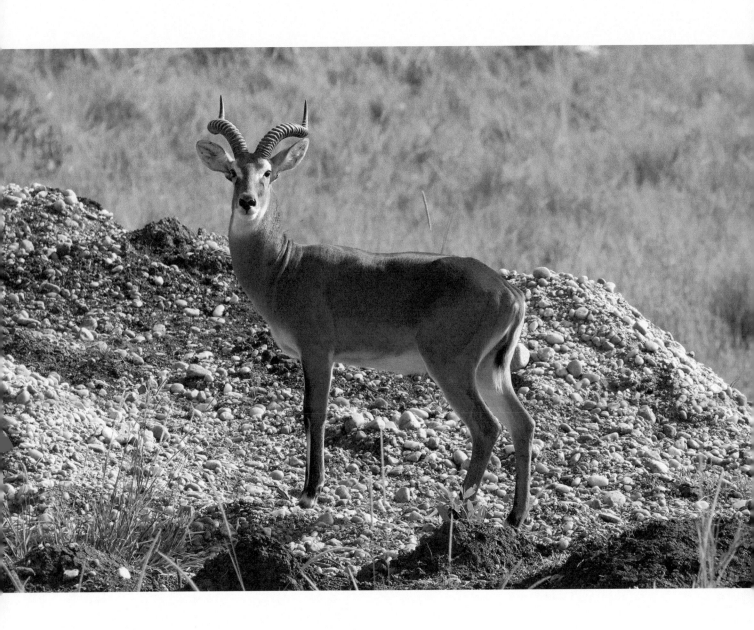

Grandma asked, "What kind of Antelope is that?"
Vicent said, "That is the Uganda Kob. It is our national animal. They live in herds of up to 100 animals."

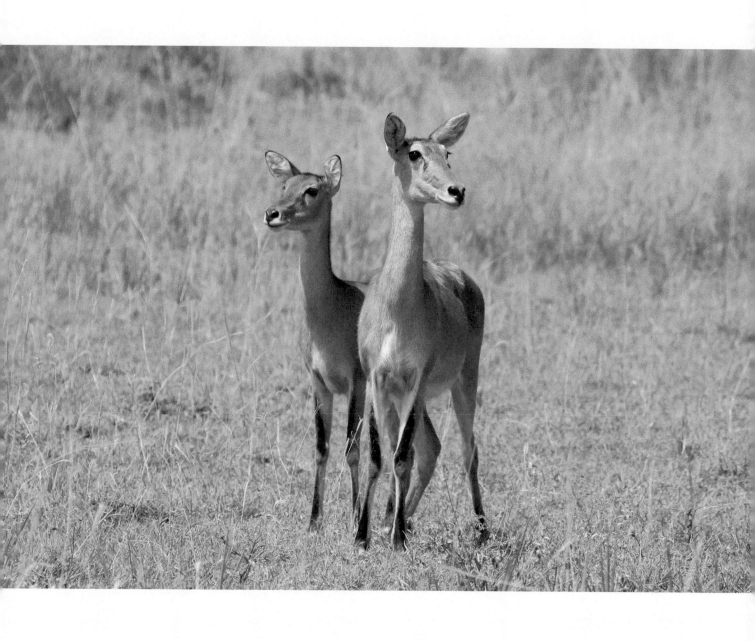

Rachel said, "Those have no horns!"
Vicent said, "They are female Uganda Kobs."

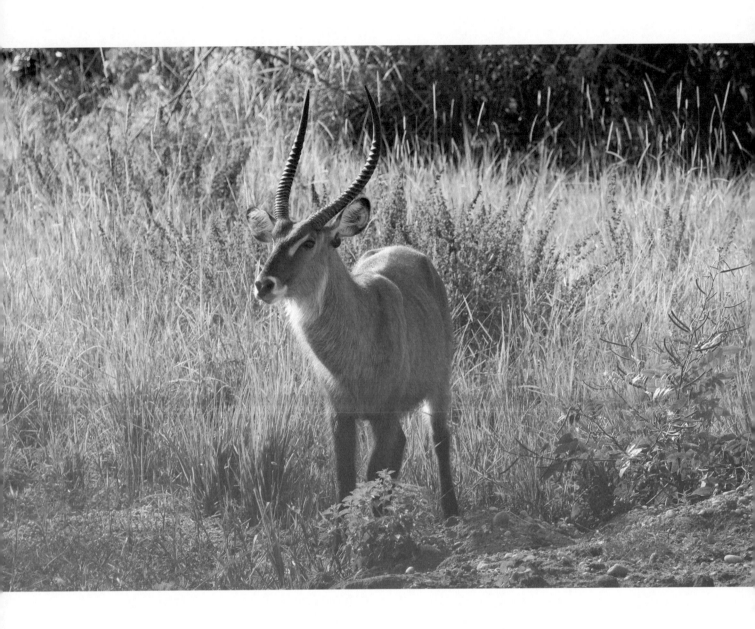

Vicent said, "That is a Defassa waterbuck male. They eat mostly grass. If they are scared they release a bad smell into their meat so lions do not like to eat them."

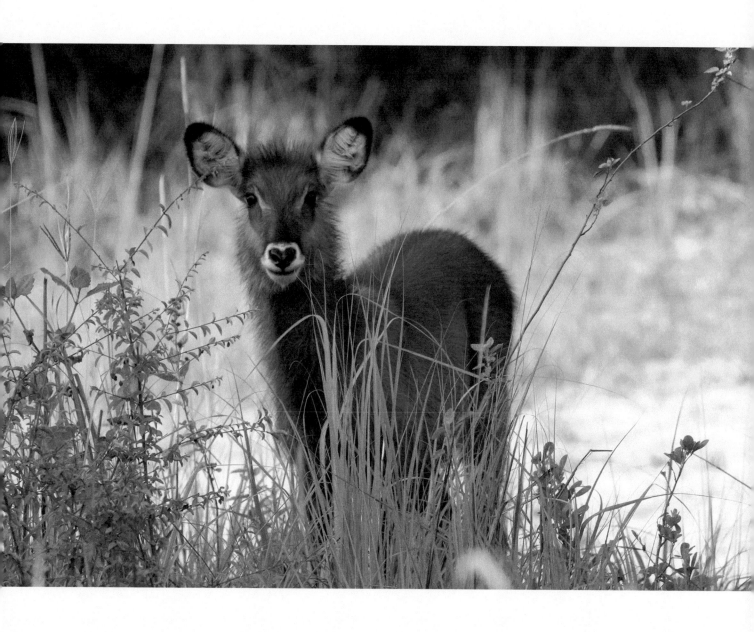

Rachel said, "There is a furry one."

Vicent said, "That is a female Defassa Waterbuck. She has no horns."

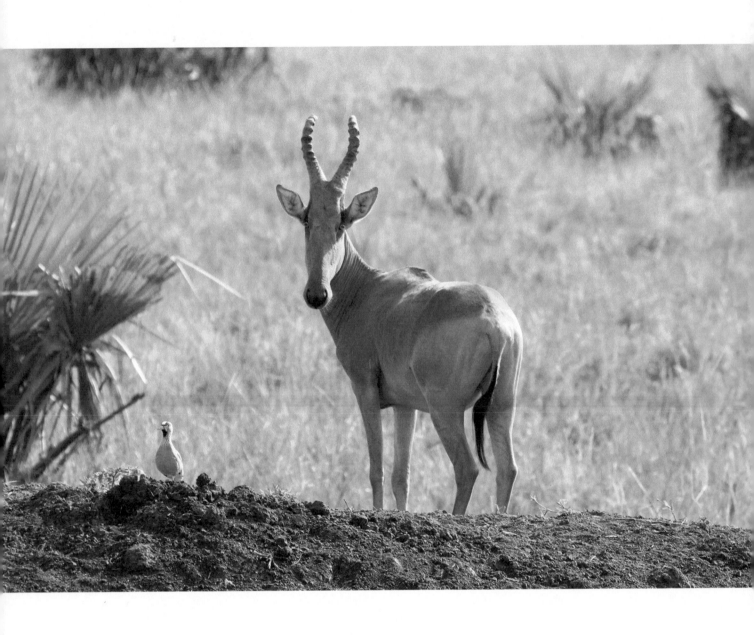

Vicent, "That is the Jackson's Hartebeest. They are only found in this area. They eat grass and they can be found with other grazing animals."

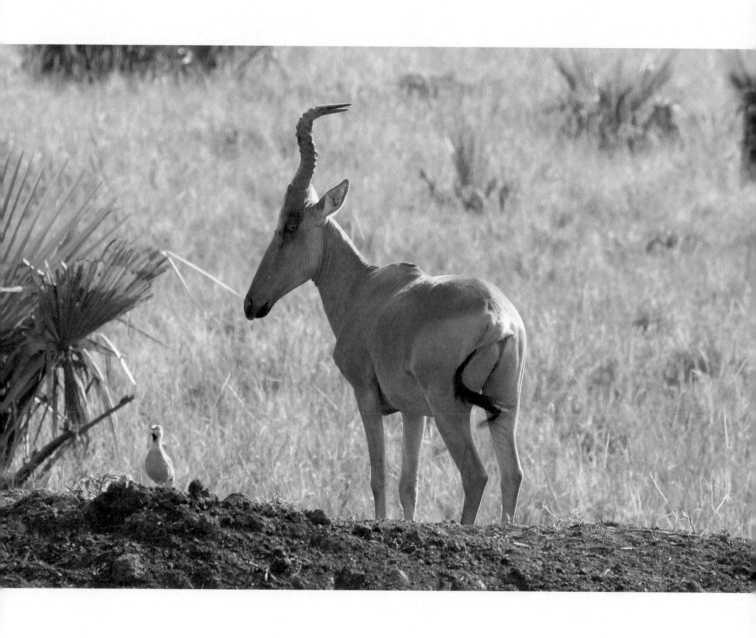

Rachel said, "He is looking at the little bird."

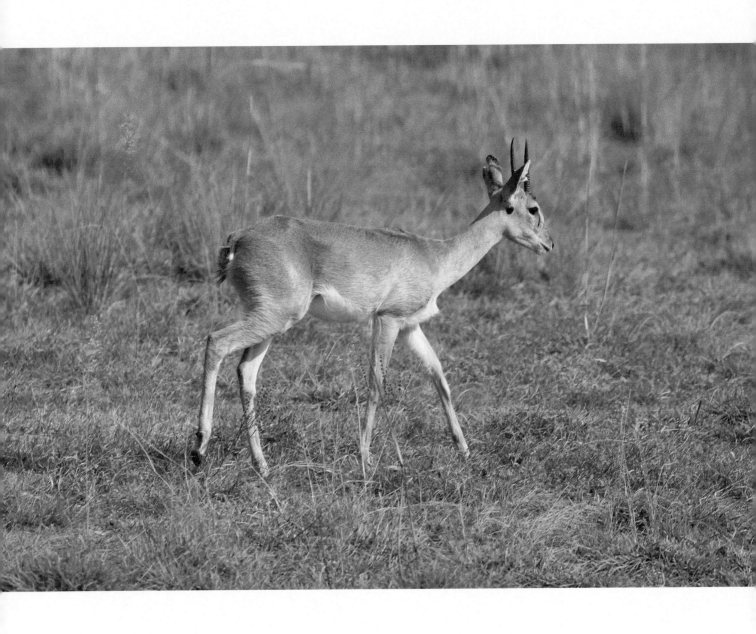

Rachel said, "Look at the tiny one!"

Vicent said, "That is the Oribi. They are small and fast.
They live in pairs or small groups."

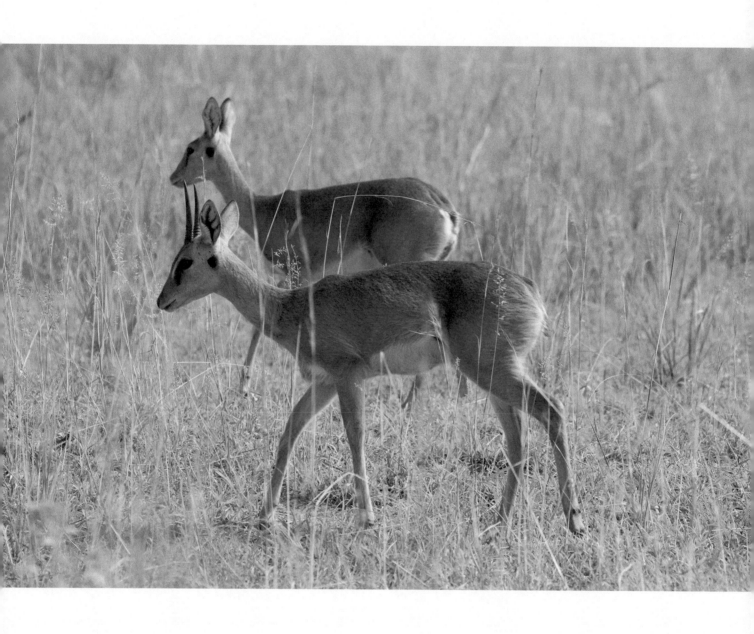

Vicent said, "There is a male and female Oribi. The female has no horns."

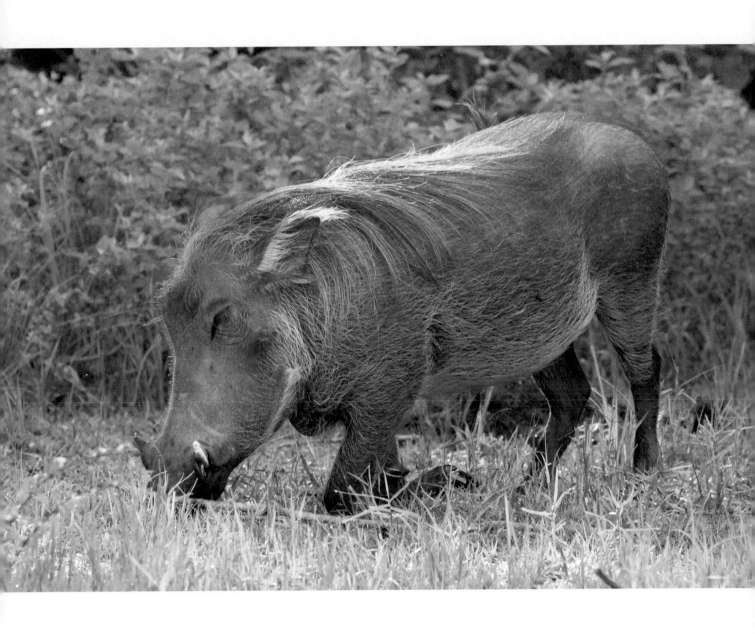

"That is a warthog. They are seen in the daytime trotting around in a family group."

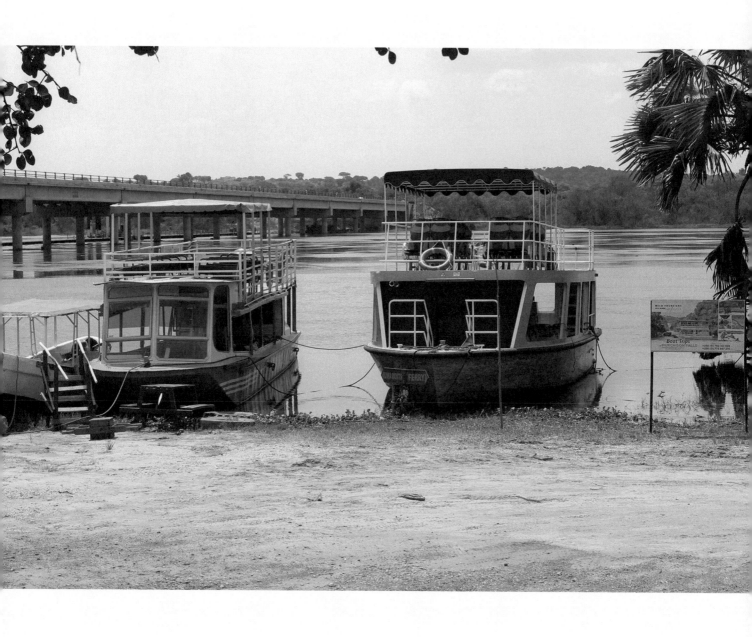

Now it was time to go on a boat ride on the Nile River!

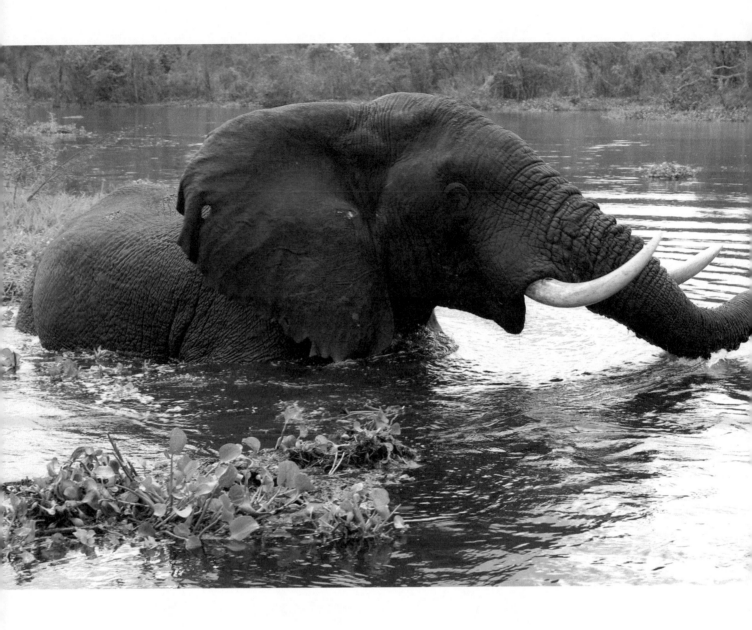

Vicent said, "Elephants use their trunks to suck up water to drink. They can also use their trunk as a snorkel when swimming. Elephants also touch their trunks to greet each other. That is how they say hello."

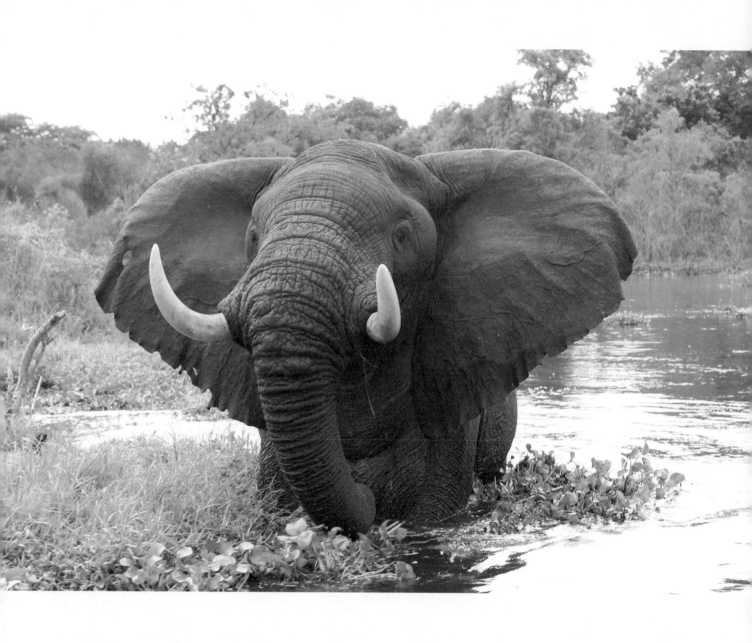

Vicent said, "These elephants have large ears which help them to get rid of extra body heat. Both male and female elephants have tusks. They are smart and they remember things for a long time. They can live to be 70 years old!"

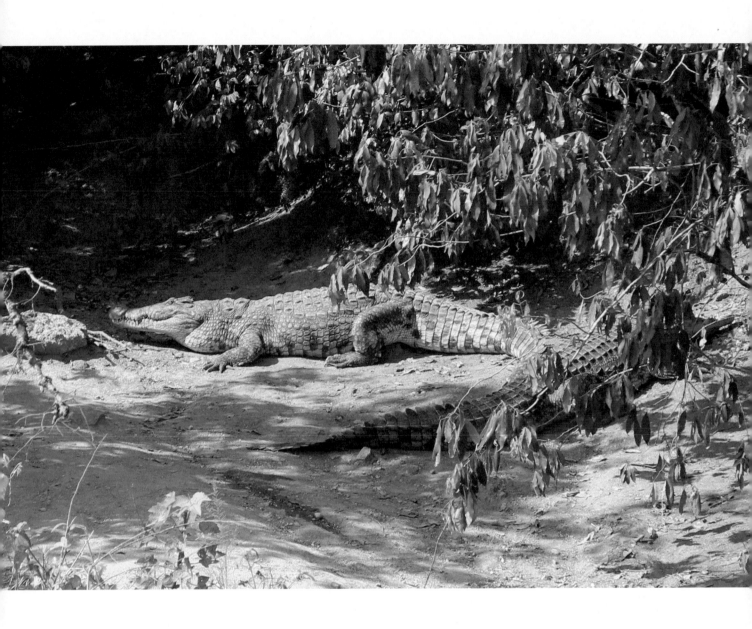

Vicent said, "They are called the Nile Crocodile. They are the largest reptile in Africa and can be 19 feet long (6 meters). They can use their powerful tail to knock an animal into the water, then turn quickly and eat it."

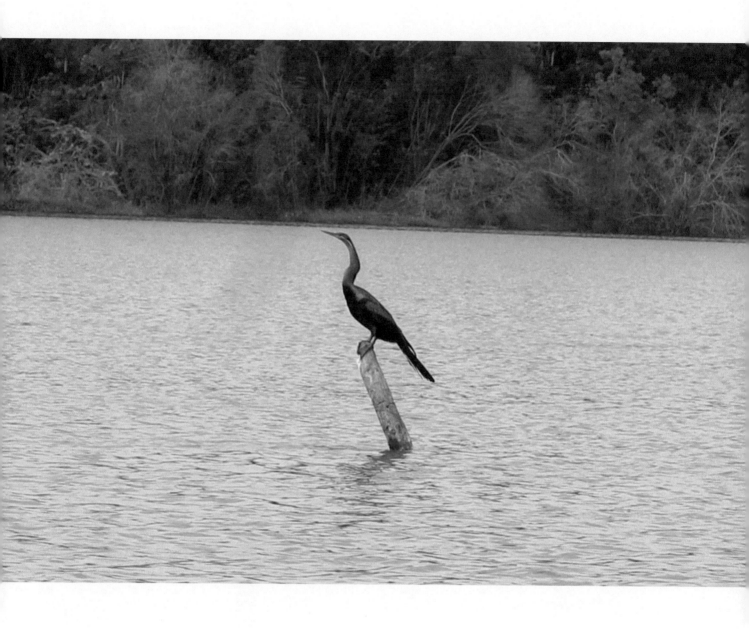

Vicent said, "That bird is the African Darter. It has a long neck. It is ready to dive into the water and eat a fish."

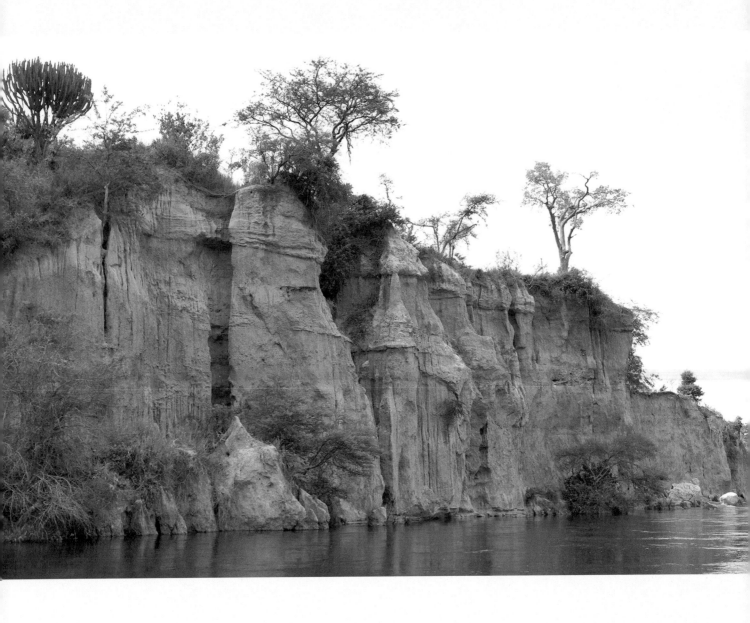

Grandma said, "Look at the beautiful cliff with trees."

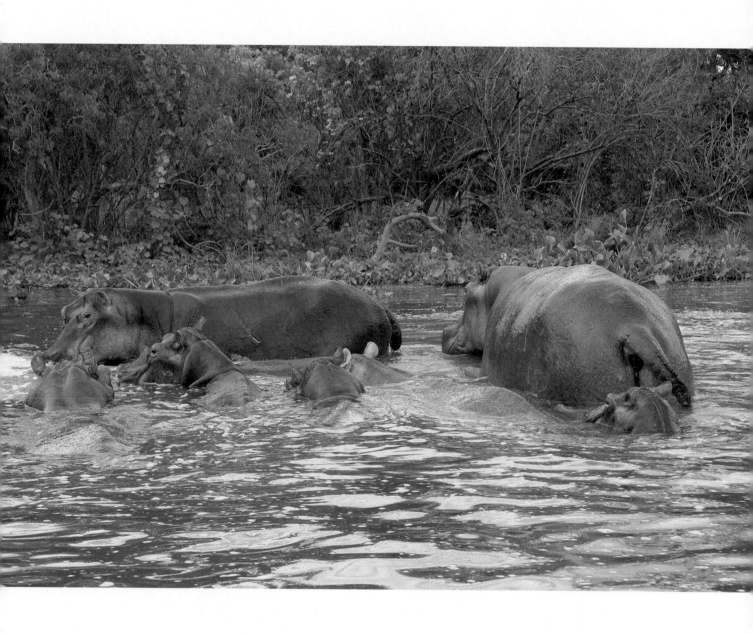

Vicent said, "That is a Hippopotomus. A group of Hippos is called a school."

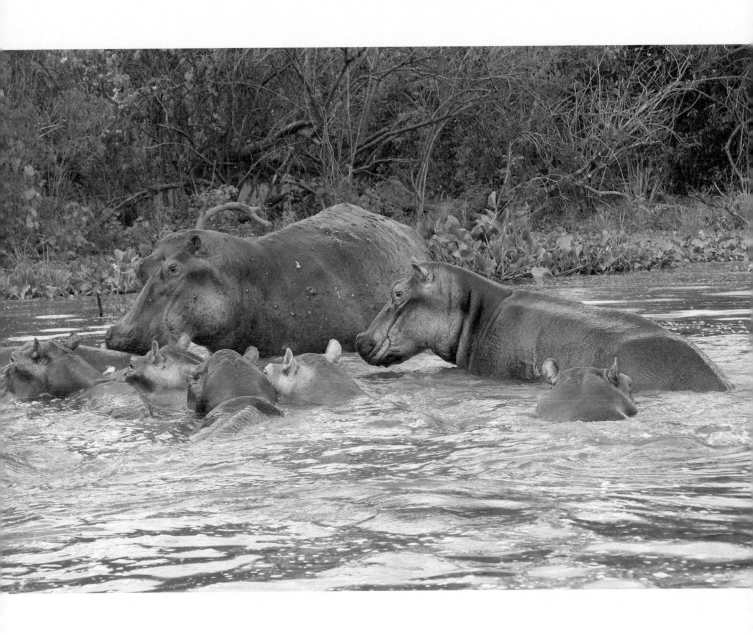

"A Hippo can hold his breath and stay under the water for 5 minutes."

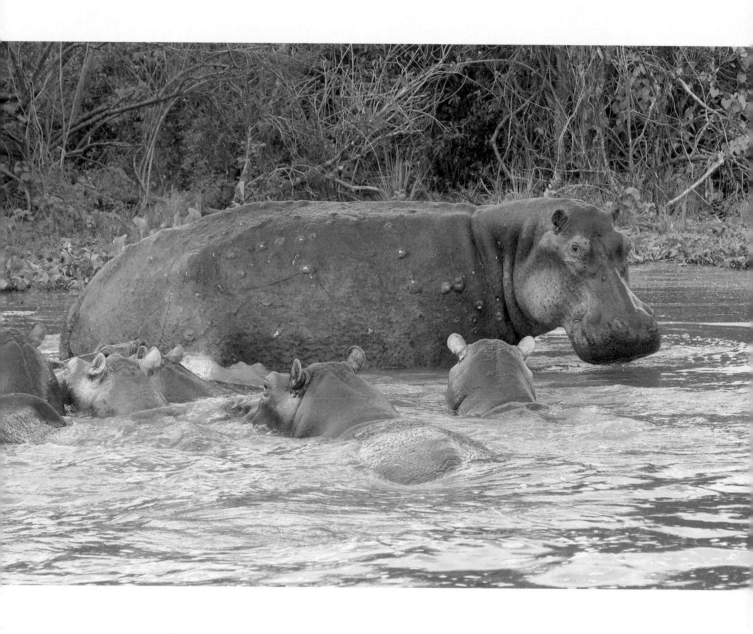

"Hippos spend most of the day in the water. They graze and eat at night."

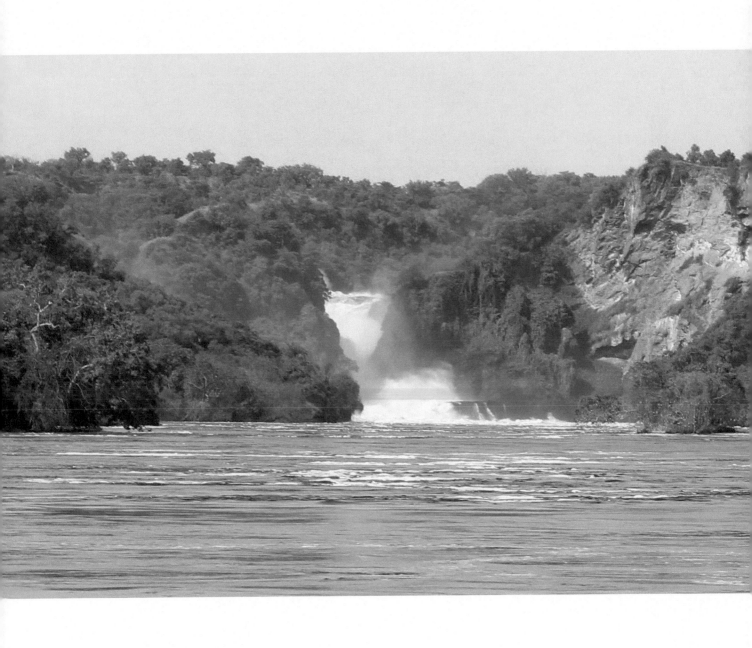

From the boat we could see the waterfall! How beautiful!

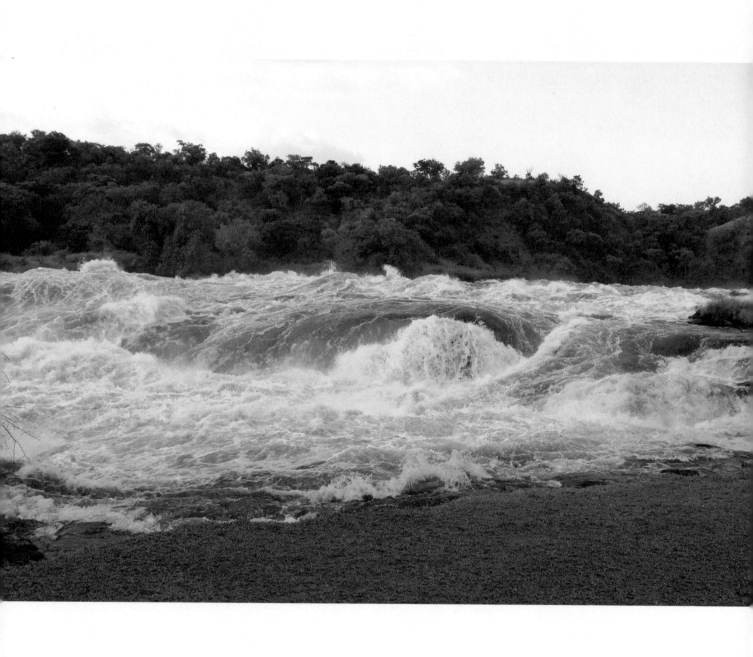

Now our boat ride was over. We took a hike to the top of Murchison Falls!

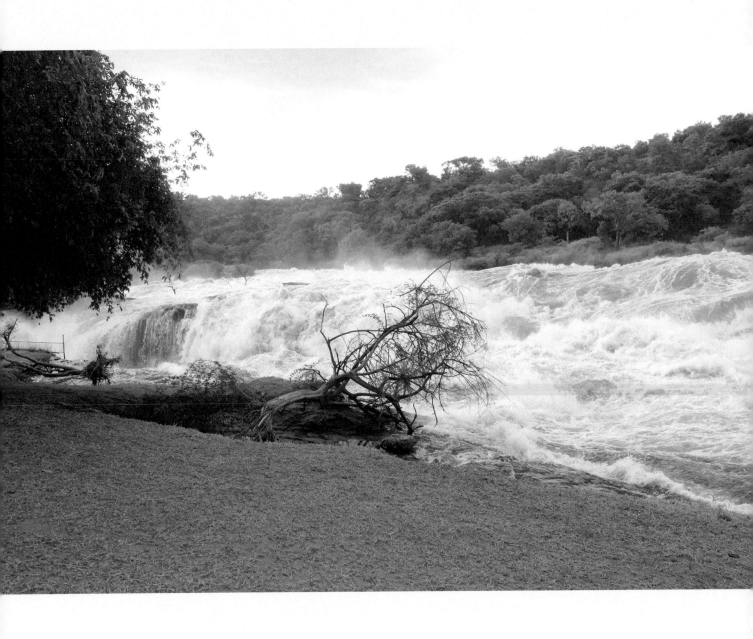

Wow! The water is moving so fast it can carry away a tree!

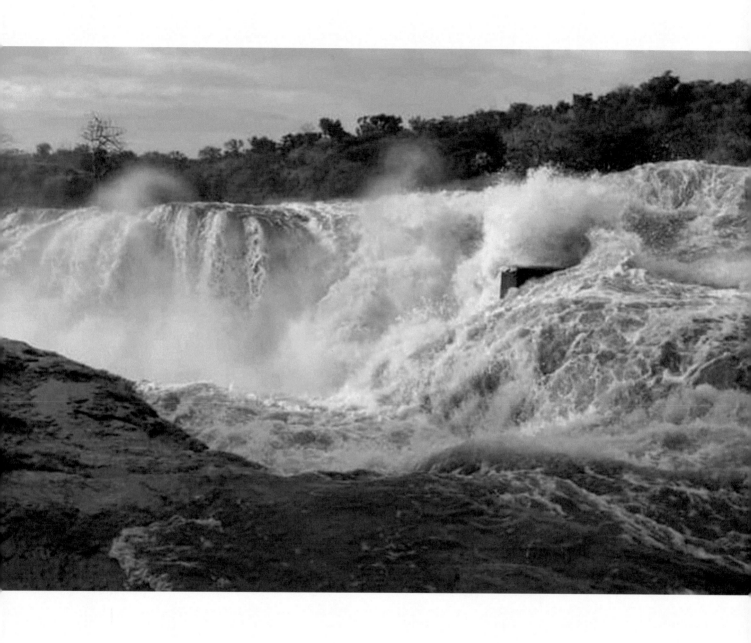

Wow! That is really amazing!

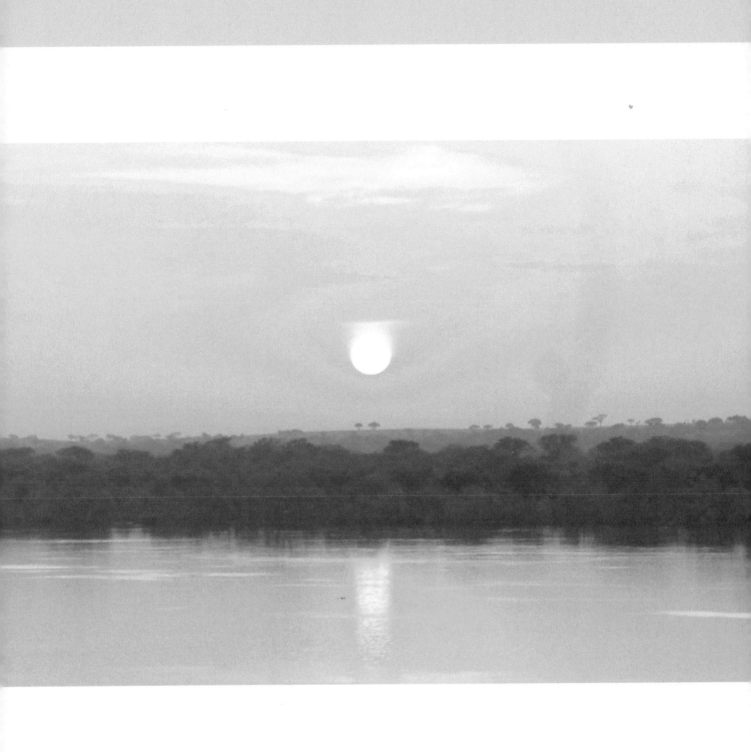

We will never forget our wonderful safari in Uganda!

AUTHOR INFORMATION

LINDA DILLON DEJONG is a nature photographer and stained-glass artist living on Camano Island in Washington State, USA. Linda is a Mom to many children from all over the world. After she became a Grandmother, Linda had the idea to write nature photography books to teach children to love our natural world that is full of amazing birds, plants and animals. Linda wants to encourage all children to get outside and experience the wonders of nature.

Linda is a Director of a Non-Profit Charity
NewHopeForAfrica.com

PHOTO CREDITS

Printed in the United States
by Baker & Taylor Publisher Services